THE WATSON GORDON
LECTURE 2015

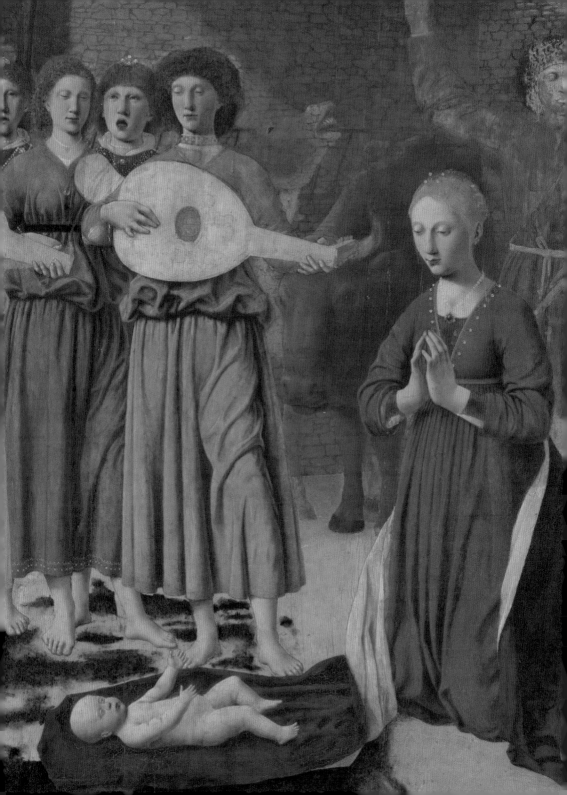

THE WATSON GORDON
LECTURE 2015

From the Masterpieces to Rooms Full of Art – and Back?

ROBERT STORR

NATIONAL GALLERIES OF SCOTLAND
in association with
THE UNIVERSITY OF EDINBURGH

Published by the Trustees
of the National Galleries of Scotland, Edinburgh
in association with The University of Edinburgh
© The author and the Trustees of the National Galleries of Scotland 2017

ISBN 978 1 911054 01 6

Frontispiece: Piero della Francesca (*c.*1415/20–1492)
The Nativity, 1470–1475 (fig.2)
Designed and typeset in Adobe Arno by Dalrymple
Printed and bound on Arctic The Silk 150gsm
by Skleniarz, Poland

FOREWORD

The publication of this series of lectures has roots deep in the cultural history of Scotland's capital. The Watson Gordon Chair of Fine Art at the University of Edinburgh was approved in October 1872, when the University Court accepted the offer of Henry Watson and his sister Frances to endow a chair in memory of their brother Sir John Watson Gordon (1788–1864). Sir John, Edinburgh's most successful portrait painter in the decades following Sir Henry Raeburn's death, had a European reputation, and had also been President of the Royal Scottish Academy. Funds became available on Henry Watson's death in 1879, and the first incumbent, Gerard Baldwin Brown, took up his post the following year. Thus, as one of his successors, Giles Robertson, explained in his inaugural lecture of 1972, the Watson Gordon Professorship can 'fairly claim to be the senior full-time chair in the field of Fine Art in Britain'.

The annual Watson Gordon Lecture was established in 2006, following the 125th anniversary of the chair. We are most grateful for the generous and enlightened support of Robert Robertson and the R. & S.B. Clark Charitable Trust (E.C. Robertson Fund) for this series which demonstrates the fruitful collaboration between the University of Edinburgh and the National Galleries of Scotland.

The tenth Watson Gordon Lecture was given on 19 November 2015 by Professor Robert Storr, Dean of the Yale University School of Art. His bravura discourse covered a wide panorama of issues in modern and contemporary art, touching on artistic practice, collecting and shifting patterns of reputation. Combining analysis and anecdote, specifics and speculation, questioning the role of the museum, Robert Storr's lecture captivated his audience.

RICHARD THOMSON
Watson Gordon Professor of Fine Art,
University of Edinburgh

SIR JOHN LEIGHTON
Director-General,
National Galleries of Scotland

FROM THE MASTERPIECES
TO ROOMS FULL OF ART – AND BACK?

When I talk about art, I am always thinking of specific objects. I have respect for theory, history and generalisations, but we always have to ask ourselves what exists to back these up. Ezra Pound (1885–1972) wrote: 'Any general statement is like a cheque drawn on a bank. Its value depends on what is there to meet it. If Mr. Rockefeller draws a cheque for a million dollars it is good. If I draw one for a million it is a joke, a hoax, it has no value.'[1] If a critic or historian makes a generalisation, it must always be closely examined to determine what, specifically, it is based upon. If a statement cannot be verified, if evidence for it cannot be readily found, we should be very wary of what they have to say. I myself am something of a 'jack of all trades', having worked in many different sectors of the art world, yet I have spent a fair amount of time in each one. It is from this combination of experiences that I draw this lecture; and, while I may have a tendency towards polemic, the point is not to be right for its own sake, but to address and perhaps resolve prevalent confusion.

I have two favourite quotes. Franz Kline (1910–1962), the American abstract expressionist painter, said in an interview with Frank O'Hara (1926–1966) that 'to be right is the most terrific personal state that nobody is interested in'.[2] The second quote is from the Portuguese writer Fernando Pessoa (1888–1935) who used over seventy alter-egos, or heteronyms, and who wrote: 'One God is born. Others die. Truth | Did not come or go. Error changed.'[3] Accordingly, we are all engaged in making interesting errors that do not preclude somebody else making a more interesting one, errors which require that none of us believe too fervently in the truth that any of us claim to possess.

In light of that scepticism I want to talk about the current situation in museums, in particular with regard to their permanent collections. My enthusiastic acceptance of the invitation to give this lecture was prompted by my first visit to Edinburgh in the early 1970s. I had travelled to England to participate in a

conference in Liverpool organised by the American Friends Service Committee and then bought a ticket to Edinburgh; I came here to the Scottish National Gallery and then to the Scottish National Gallery of Modern Art, and I was bowled over. This was then, and I think remains, my idea of the perfect classical museum, in terms of the artworks, their range and quality, and the intimacy of the whole experience. Much of what I say is not applicable to places like this at all, yet I am glad they exist in this world and that there are a few of them left. The Frick Collection in New York is another excellent example.

I have a high regard for museums and yet it is clear to me that they have significant problems. These problems are not necessarily inherent. My conviction that there is no such thing as The Museum originates in the fact that there is no such thing as a universal archetype for such institutions, a Museum with a capital 'M'. There are many kinds of art museums, each with their own histories, constituencies, mandates, collections and so on. Therefore, in so far as it is possible to make certain careful generalisations, the museums that run well do so for very specific reasons: namely, that they stay close to their mandates, to their wealth in material objects, to certain attitudes toward exhibition practice that are built into their DNA. If a specific museum departs from its heritage in ways that improve on or usefully qualify what they have already achieved, rather than for the sake of gratuitously attempting to reinvent the idea of the museum, then I have no complaints; as I said, 'The Museum' does not exist, and any given museum, is not just an idea but a body of work in a building and location with their own distinct qualities.

Of the many different types of museums, all are under attack or unforgiving scrutiny. The entire branch of scholarship known as 'institutional critique' is the result, and some of it is extremely interesting. Institutional critique is most often carried out in realms of great abstraction, of sociology and theory. Consequently it tends to be highly streamlined. Real institutional critique, however, is best done within institutions. The things that question our assumptions about art and its relationship to society are never asked in a better context than in the very institutions which have established and maintained the existing models. Unsurprisingly, this is why many of the people who are engaged in institutional critique are on the inside and are in fact throwing stones at their own glass houses; they are

FIG.1 | RAPHAEL (RAFFAELLO SANZIO DA URBINO) (1483–1520)
The Virgin and Child ('The Bridgewater Madonna'), c.1507
Oil and gold on canvas, transferred from panel 81 × 55 cm
Scottish National Gallery, Edinburgh; Bridgewater Collection Loan

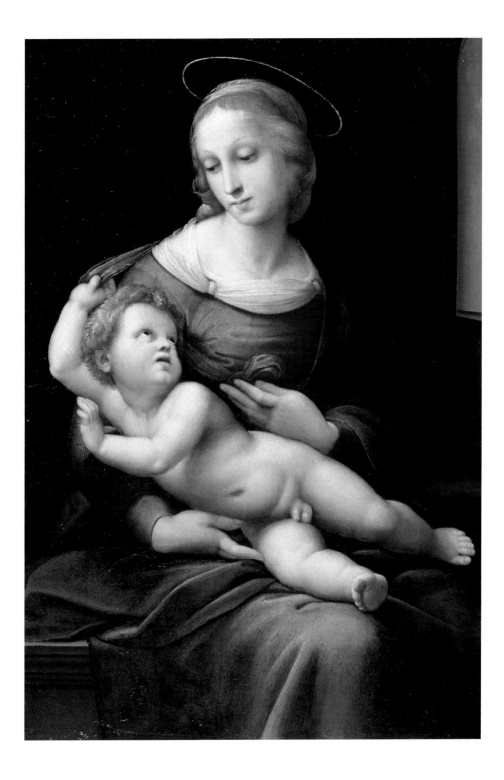

curators taking aim at the very institutions in which they work – like me. If you have an objection to something that exists, and if it is something that you really care about, then you should try to bring about improvement, or at the very least, change, where you already are. Most museums – including the National Galleries of Scotland, to a degree – were predicated on the idea that we know what quality in art is, that there is a handed-down, agreed-upon, settled list of artists and works and that the canon is something that can be relied upon. I both agree and disagree with this. In this collection, there are undoubtedly canonical images whose status few would dispute. There are also pictures by artists who were not as good as those who were responsible for the canonical images, and although these other works would not be discarded, it would have to be said that they are not of unimpeachable quality or ambition. In *ABC of Reading* (1934) Pound also said that in evaluating a work one should not only consider the ambition of the artist but also the ambition of the reader or, in this case, that of the viewer: how badly does the viewer want something, and how exigent will they be in relation to something they are given? Mediocre pictures are admired because people have a desperate need to admire and they devote that need to things that are undeserving of it.

There are also those artists who were never part of the canon in the periods when the canon was being created. There was a point when Raphael (1483–1520) was the ne plus ultra of a certain kind of classical Renaissance composition, execution and narrative painting (fig.1). The artists who had not achieved that degree of sophistication in all areas of painting were termed the 'Primitives', and were given a lower status in museums, if they were in museums at all. One of the greatest painters of the Renaissance was Piero della Francesca (*c*.1415/20–1492) (fig.2) yet his standing was not generally agreed upon until the end of the nineteenth century and the beginning of the twentieth, in part because of the way people then began to think about geometry in art, because of Cubism among other things. And so it was that the so-called 'Primitives' moved into the canon. This is easily forgotten, since there are always artists being 'retrieved'; El Greco (1541–1614) is another who was redeemed for the canon by artists as much as by art historians (fig.3).

It can be said, then, that even in great classical collections of European art, definitions of quality are mutable. Connoisseurship is predicated on the idea that

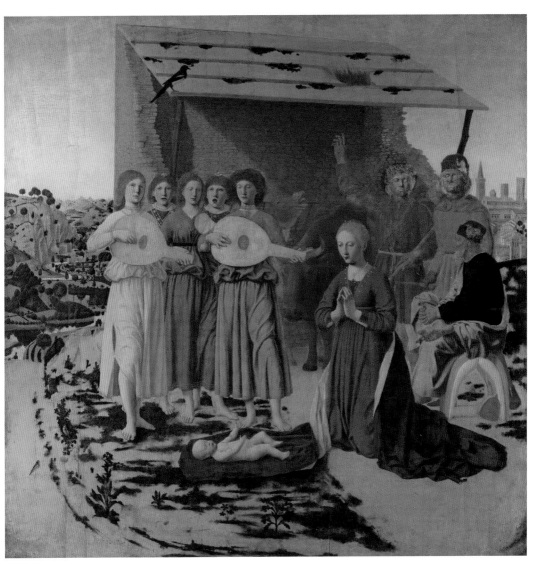

FIG.2 | PIERO DELLA FRANCESCA (c.1415/20–1492)
The Nativity, 1470–1475
Oil on poplar 124.4 × 122.6 cm
National Gallery, London; Bought 1874

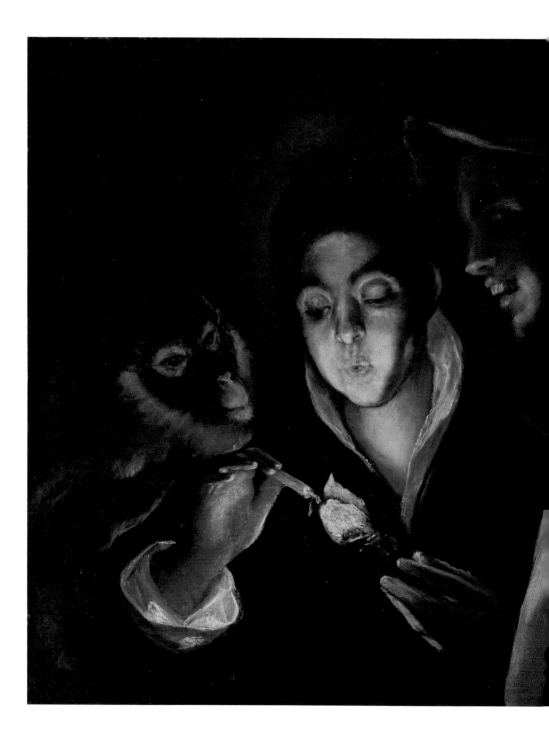

FIG.3 | EL GRECO (DOMENIKOS
THEOTOKOPOULOS) (1541–1614)
An Allegory (Fàbula), c.1580–1585
Oil on canvas 67.3 × 88.6 cm
Scottish National Gallery, Edinburgh; Accepted in lieu of tax,
with additional funding from the National Heritage Memorial
Fund, the Art Fund and Gallery funds 1989

there are disagreements among the experts and that the relative value of works even by those individual artists who are universally accepted continues to be disputed. This is no bad thing; in fact, it is a very good thing.

This principle can be taken forward in time to Lincoln Kirstein (1907–1996), an important figure in American cultural history. He was heir to the Filene's department store fortune, as well as a connoisseur of many things and a great patron of the arts. In the 1920s, alongside a number of his classmates, he founded the Harvard Society for Contemporary Art. Alfred H. Barr, Jr (1902–1981) was around at that time, teaching at Wellesley, and he was aware of the activity of these young Harvard men, all men of wealth and taste. He learned lessons from them, and from their Society; these were lessons he used when, at the end of that decade, he went on to create The Museum of Modern Art in New York (MoMA). In his statement written for the opening of the Society's first exhibition, Kirstein stated that their aim was 'to exhibit to the public works of living contemporary art whose qualities are still frankly debatable'.[4] The idea that the whole purpose of the exercise is to foster debate about values is, I think, the principle that gets lost all too easily in discussions of contemporary and modern art. What happens is that, after a period of time, there is acceptance; that acceptance then becomes institutionalised, it becomes orthodoxy, and then among experts in the field debate ensues about related matters but not about the fundamentals. That which was wild and woolly and untamed is suddenly almost entirely house-trained, and then becomes the subject of duels between professionals over their professional stake in these artworks: not necessarily over what they are really there for in the first place or continue to be in the present time.

Periodically, works of art die, like anything else. When they are dead, they are dead. Other works of art do not die but go into a kind of turnaround, as they call it in Hollywood, where someone is out of fashion for a long time before making a return. This is the case of a lot of postmodernism, which is in fact not postmodern at all but rather a matter of the return of the repressed, the resurgence of tendencies or styles that were thought to have 'lost' previous struggles for dominance. Moreover, there is no agreement on who the first modern artist was, or what the first modern work was. I would point to Francisco de Goya (1746–1828)(fig.4);

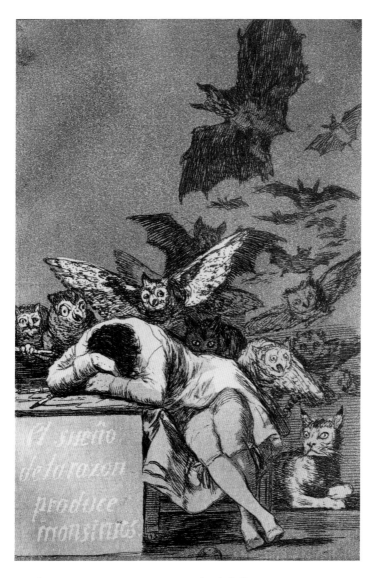

FIG.4 | FRANCISCO DE GOYA Y LUCIENTES (1746–1828)
The Sleep of Reason Produces Monsters, 1797–1798
Etching and aquatint 21.5 × 15.0 cm platemark, 30.4 × 20.8 cm sheet
Bibliothèque Nationale, Paris, France

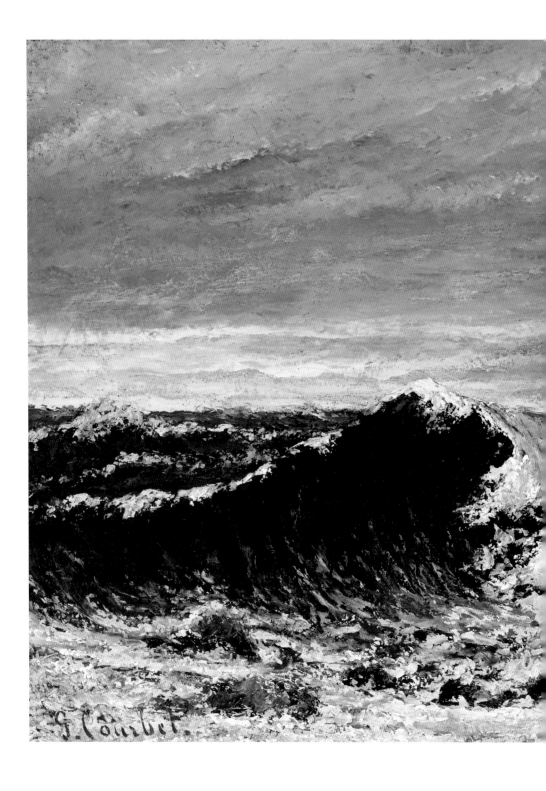

FIG.5 | GUSTAVE COURBET (1819–1877)
The Wave, c.1869
Oil on canvas 46 × 55 cm
Scottish National Gallery, Edinburgh; Presented
by Sir Alexander Maitland in memory of his wife
Rosalind 1960

other people would say it was Gustave Courbet (1819–1877)(fig.5) or Édouard Manet (1832–1883). Historians of Europe, meanwhile, talk about the early modern period beginning with the Renaissance.

So what is the modern period? We cannot say when it started and, more importantly, we cannot say when it ended. We are now finding that after several generations of scholars of postmodernism, none of them agree on when it begins, none of them agree on any of the major issues about what it consists of and, lo and behold, almost everything they believe to be categorically postmodern closely resembles things we find in modernism. I have concluded from this that postmodernism is symptomatic of modernism's midlife crisis; all the old ideas are returning as if they are brand spanking new, which they are not. It would be better to set aside the concept of definite periods of apocalyptic modernism and simply say that modernist culture – be it visual, literary, musical – exists within a very large timeframe. It is a product of the rise of the bourgeoisie and the mercantile classes, even though much of the work was a rebellion of those classes. If we relax and accept the idea that we are in a long, variegated period, we can look at history the way Fernand Braudel (1902–1985) did in terms of long periods of time rather than short ones, thus becoming less tempted to make generalisations we cannot sustain, wasting less time disputing them and spending more time looking into that which they are supposed to summarise.

In my view museums are the places where the arguments among different artists, schools, and philosophical systems about what art should be – and more specifically about what modern art is or should be – ought to take place, and in the best cases do. To a greater or lesser extent, artists and schools of artists make propositions by creating works demonstrating what something might be if it was actually realised. If you see things that way, you can be comfortable walking through the galleries at MOMA – or any museum – devoted to early abstraction (such as De Stijl, Suprematism, Constructivism and some of the other geometric styles of the mid-1920s and 1930s) and grasp that Kazimir Malevich's (1878–1935) art is not categorically different from that of Piet Mondrian (1872–1944) and others, no matter how hard any of the protagonists argued for clear distinctions. Meanwhile, the boundaries of Dada conflate with those of Surrealism, which in turn blurs

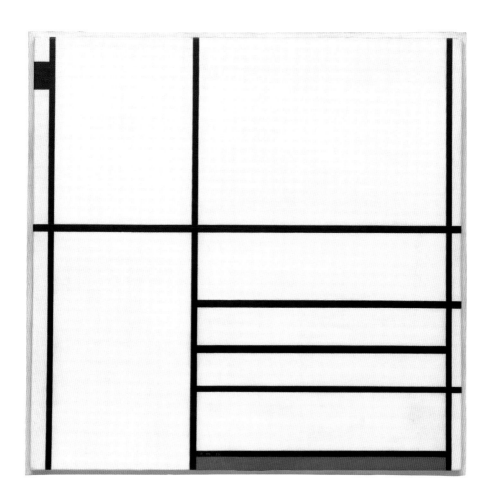

FIG.6 | PIET MONDRIAN (1872–1944)
Composition in White, Black, and Red, 1936
Oil on canvas 102.2 × 104.1 cm
The Museum of Modern Art, New York; Gift of the Advisory Committee

with Magic Realism and the Neue Sachlichkeit. In divergent but also intersecting ways, all of these tendencies were trying to grapple with the 'real' as defined by the prosaic naturalism of the nineteenth century while simultaneously pushing off from it in various directions. Meanwhile, you have people like Jean (Hans) Arp (1886–1966), who was a member of the surrealist circle but who was highly valued by De Stijl, commuting among all these different areas (figs 6–9). Under these comingling conditions, the 'camp-follower' idea – that is, the claim that any particular artist represents just one thing, while another only represents something else – simply falls apart. If you walk through museums of modern art – Tate Modern in London, the Musée National d'Art Moderne at the Centre Pompidou in Paris and so on – you should hear a murmur of people arguing intimately over what matters, with none of them winning the argument. As I said, truth did not come and go: error changed. The things that are 'right' about certain movements are also the things that are 'wrong' about them; the ways in which they were not successful left paths open for other movements to chart tangential courses, to formulate alternative definitions of what modern art should be.

If that is the case then we have plenty of room to manoeuvre; as artists, critics, members of the public, we can detest something and still find it interesting. We can love something while acknowledging its failings. We can agree with Henri Matisse (1869–1954) that a painting should be like an armchair into which a tired businessman could settle at the end of the day, and also agree with the Russian Productivists who strived to make well-designed utilitarian objects for ordinary workers and rejected the notion that art should be mere decoration (figs 10 & 11). Nothing 'logical' prevents us from entertaining such conflicting views sequentially or even simultaneously. As F. Scott Fitzgerald (1896–1940) said, 'The test of a first-rate intelligence is the ability to hold two opposed ideas in the mind at the same time, and still retain the ability to function.'[5] Those people who are trained to marshal our ideas in art do not like that a bit. They rebel and scorn people who hold conflicting views, yet most of us do so regardless because we find ourselves attracted to opposing things, things we know we should not like, or that have not been prescribed by authorities. I love the grotesque for this very reason. In it antitheses are fused and prevented from separating; in its presence viewers are

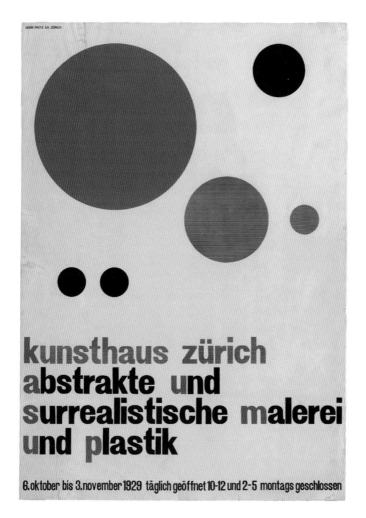

FIG.7 | JEAN (HANS) ARP (1886–1966) AND WALTER CYLIAX (1899–1945)
Kunsthaus Zürich, Abstrakte und Surrealistische Malerei und Plastik, 1929
Lithograph 128.3 × 90.5 cm
The Museum of Modern Art, New York; Special Purchase Fund

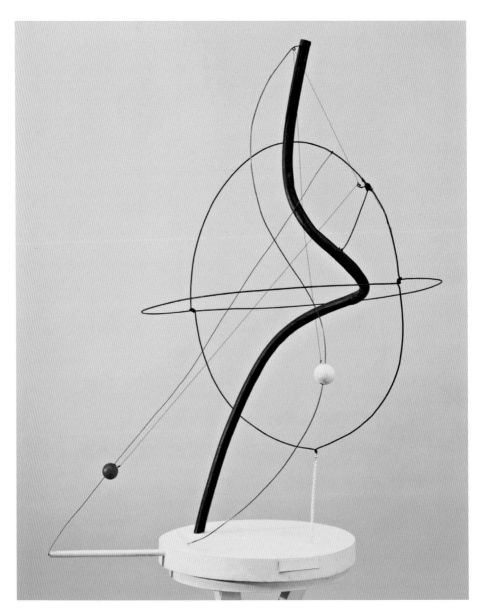

FIG.8 | ALEXANDER CALDER (1898–1976)
A Universe, 1934
Painted iron pipe, steel wire, motor and wood with string 102.9 × 76.2 cm
The Museum of Modern Art, New York; Gift of Abby Aldrich Rockefeller (by exchange)

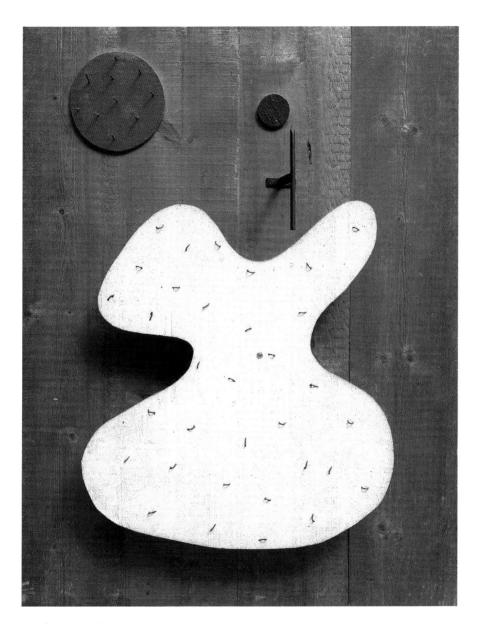

FIG.9 | JOAN MIRÓ (1893–1983)
Relief Construction, 1930
Oil on wood, nails, staples and metal on wood panel 91.1 × 70.2 × 16.2 cm
Artist's estate

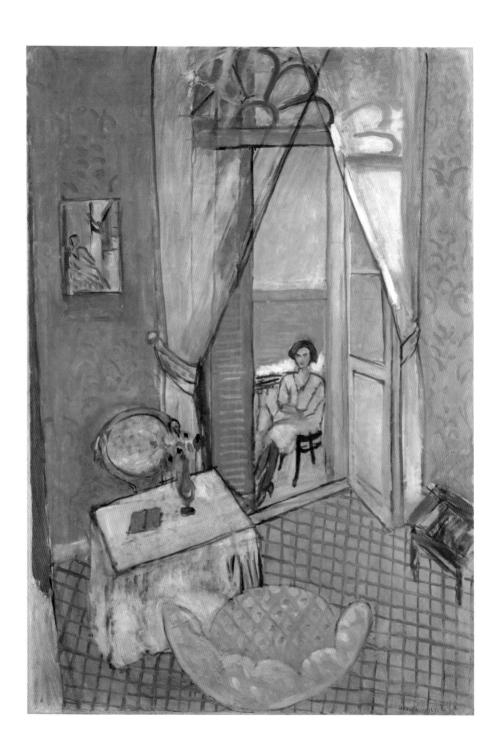

caught in the contradictions of their own sensibility and desire. The history of art is so fluid, so convoluted, so full of opportunities for entrapment that careful consideration of this fact provides an inexhaustible source for imagining different ways to install works in exhibitions.

Nowadays there is a tendency among my colleagues to suppose that a curator's job is to tell a story or make an argument and that exhibitions are in that sense unidirectional. They must be conclusive and correct on the big issues, thus providing a chance for experts to dictate to the audience what they should see and what they should think. For my inaugural show at MOMA, DISLOCATIONS, Sophie Calle (b.1953) recreated her work GHOSTS which was originally made for the Musée d'Art Moderne de la Ville de Paris (fig.12).[6] In each case she asked people to describe canonical works in the museum's collection that for some reason or another had been removed from view and then asked them to sketch the image as they remembered it. Subsequently she made schematic line drawings of the selected work plus a fanciful graphic frame, projected them onto the wall, and then, within the exact space of that painting with her faint image of the missing canvas, she laid down the texts and arranged 20 × 25 cm notecards with the drawings. To provide these surrogates Sophie called upon cleaners, carpenters, members of the public, curators and educators. At MOMA, she focused on paintings by artists such as René Magritte (1898–1967) and Edward Hopper (1882–1967). Visitors stood and stared at these images and relived their memories of the works through the filter of other people's memories, learning the basic lesson that there is no objective, definitive view of anything. Correspondingly, curators must first come to terms with the fact that they are dealing with artworks that disagree with one another about fundamentals. Secondly, they must grapple with works that are more or less fully realised versions of well-articulated ideas, works that are almost perfectly formed and open to interpretation and misunderstanding. Sometimes the less fully realised versions of a given concept reward scrutiny more. In a picture that is less successful as a whole yet emphatically consecrated to one aspect of an aesthetic or a situation, that particular element can sometimes be seen for itself with far greater clarity.

In my 2002 MOMA retrospective of the work of Gerhard Richter (b.1932), I

FIG.10 | HENRI MATISSE (1869–1954)
Interior at Nice, 1919–1920
Oil on canvas 132.1 × 88.9 cm
Art Institute of Chicago

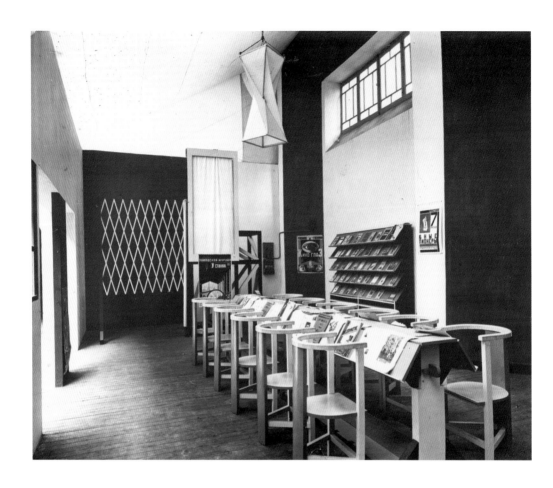

FIG.11 | ALEKSANDR RODCHENKO (1891–1956)
Interior of the Workers Club (design A. Rodchenko)
Soviet Pavilion, International Decorative Arts Exposition
Paris, 1925
Photo paper, Gelation Silver print 48.8 × 58.2 cm
Moscow Museum of Modern Art (MMOMA)

showed a couple of questionable pieces. Yet these were fascinating and they were proof that Richter was willing to make disagreeable pictures (fig.13), at just the time when people were saying that he only made good-looking, resolved artworks. They were included because they were interesting in and of themselves but they also served as counterpoints to the things that people had become lazy about looking at.

Edmund Burke (1729–1797) wrote of the difference between beauty and the sublime; for him the sublime is bigger than us, unpredictable and potentially threatening. We do not tire of the sublime because we must remain alert in its presence, whereas we may get used to looking at beauty, which is smooth and proportionate, and eventually lose interest. Many modern artists deliberately put you in this same predicament, emphasising things that are alien and overwhelming, things that will have a disturbing effect on you whether you like it or not. Museum curators can orchestrate those different factors in the quality, intent and clarity of works of art which are good enough to be worth our attention, but that may not all be great. Interspersed with works that almost indisputably are, they remind the viewer that not everything is a masterpiece and that there is real value in art that is lesser. The minor masters are often the masters we come back to with the greatest affection, even though the major masters should theoretically absorb the whole of our attention. There is much satisfaction to be had in a Giorgio Morandi (1890–1964) painting that cannot be found in the heroically ambitious paintings of that time (fig.14). If we hold that the modernism that matters was a dynamic machine marching through time, then where is the place for the poetic stasis of Morandi? Yet many people looking at Italian art of that period will end up admiring him over and above the bombastic work of the Futurists. Of course, the future did not turn out the way they envisaged it and instead of predicting what the world would look like, their art became a historical *memento mori* of their illusions about what the future should have looked like.

The minor masterpiece and the major masterpiece should be part of the same museum experience because, while we may go there to expose ourselves to certified 'greatness', we may well linger longer and think more deeply about 'lesser' discoveries. As a spectator one need not agree with artists about anything; moreover,

FIG.12 | SOPHIE CALLE (B.1953)

GHOSTS. Composed of GHOST (de Chirico: The Enigma of the Day), GHOST (Hopper: House by the Railroad), GHOST (Magritte: The Menaced Assasin), 1991

Oil, synthetic polymer paint, graphite and silkscreen ink, and colour laser prints. Overall dimensions variable. GHOST (de Chirico: The Enigma of the Day) 231.1 × 210.8 cm, GHOST (Hopper: House by the Railroad) 96.5 × 121.9 cm, and GHOST (Magritte: The Menaced Assasin) 208.3 × 233.7 cm

The Museum of Modern Art, New York; Gift of The Bohen Foundation

I remember an open space, a piazza. In the middle of this composition there is a gray statue of a man wearing a long coat on a bulky body, something very ungainly. The size brings to mind a monument, although the figure looks more like some tourist lost in that piazza. To the left, there is a brick building with an arcade, one of those standard de Chirico structures. It looks paper-thin, more like a prop than anything real. And on the other side, there is a big yellow trunk. Somewhere in the painting, I remember two tiny figures projecting long, dark shadows. It reminds me of a stage set; there's a sense of suspended time, suspended animation. You have the feeling that you are not in reality, you are on a film set, and something is wrong. There's a terrific suspense that something is going to happen, something is going to appear in that picture, and everything will eventually make sense, but nothing does. I can't remember if there is a train. There is almost always a train. It's an abandoned city inhabited by shadows. Pretty much his usual stuff. Psychological things. Surrealistic, dreamlike imagery. It has a beige color, a little blue in the sky, and that's all. It's a chilly painting because it's so empty. There's a landscape, a scenic view of some strange things, a masked face, a man looking like a hostage with a sheet over him, a feeling of isolation. That's all I can remember. It reminds me of a TV show called "The Prisoner." The story of a man trapped in a ghost town. I draw a blank. I simply don't remember it. It's a vertical painting, around six feet by five feet. Very sterile, very angular. There are architectural elements, a colonnade of black arches off the roadway, a child playing with a hoop, and a statue of a man with his hand stretched out a little, pointing to a crate. The title reflects the image, but where is the enigma? Is it this very innocent figure, playing a game in the midst of this surrealistic place? The painting is cold, confidential, not very inviting. It's too intellectual, too studied, too much. When I look at it, I always think of a university text. It's very somber, geometric. The color is depressing. It's not what I like — it's never more than a B. It doesn't have instant dramatic appeal. It's mostly those typical de Chirico colors, mustard, gold, brown, and blue. There's not much life in that one. It's an abandoned city that you would expect to be dirty and black, and this one is impeccable. It feels like the air has been sucked out. There is not a single cloud in the sky, nothing between you and the object. There is an uncanny atmosphere of silence in this picture.

FIG.13 | GERHARD RICHTER (B.1932)
Busch, 1985
Oil on canvas 65 × 80 cm
Howard and Linda Karshan Collection,
London

one must expect to contend with significant discrepancies in ambition, quality and so forth, in addition to substantial conflicts among ideas within any given body of work. As a curator, if you do not know what the methods and motives were for a given work, if you do not know the biography of the artist or anything about the historical moment that produced it, you can be in very big trouble. Yet, even if you do know that, it is not necessarily going to determine your response; indeed the work may be compelling for reasons one cannot readily fathom or explain.

There was a time in the 1960s when makers of abstract art would claim that the goal of abstraction was to solve the formal problems inherent in art's development up to one's own point of departure. Frank Stella (b.1936), who recently had a retrospective at the Whitney Museum of American Art in New York, was a prime case of this (fig.15). He purported to know where abstraction had to go and which fundamental issues were driving it there. His oeuvre consists of a series of chapters devoted to each of the problems he identified and 'solved'. On the other hand, Chuck Close (b.1940) recalled a conversation he had with Richard Serra (b.1939) when both were at Yale. Chuck was then in the problem-solving mode and Richard said to him, 'No, problem creation is what we're about, not problem solving.' That distinction is important for artists to remember. People like Stella have landed themselves in trouble from trying to solve the problems of art history, rather than creating problems that are greater than any of the 'lessons' they have extrapolated from history. This is also true for viewers; if visitors go to museums trying to find answers to the riddles of art history, they are going for the wrong reason. If they go there to begin to problematise their own taste, to problematise the explanations they have been given by other people for why this work exists, they will have a very good time. They will also learn a lot and begin a process that will continue far past that particular encounter. Most importantly, they are more likely to come back. People used to visit MoMA during their lunch hours, before there was a twenty-dollar admission fee, and the idea of the museum was that it was not a treasure house, or a temple, or a collection of chapels dedicated to individual artists or patrons. It was nothing resembling that; it was a public library of the visual culture of the modern era. The public could come to it as they would

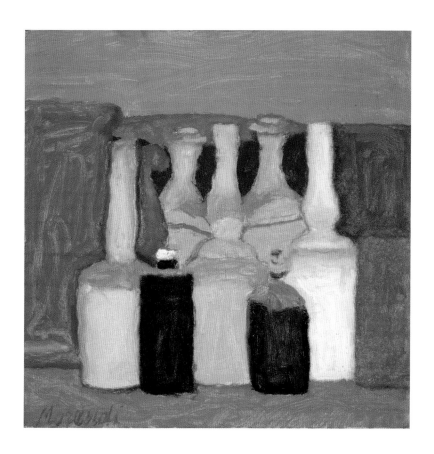

FIG.14 | GIORGIO MORANDI (1890–1964)
Natura Morta (Still Life), 1962
Oil on canvas 30.5 × 30.6 cm,
framed 47 × 47 × 6 cm
Scottish National Gallery of Modern Art; Purchased 1965

FIG.15 │ FRANK STELLA (B.1936)
Arbeit Macht Frei (Black Series), 1967
Lithograph on paper
Scottish National Gallery of Modern Art;
The Henry and Sula Walton collection:
bequeathed 2012

come to the reading room of a great public library and spend time with particular works. You cannot check the books out or take them out of the stacks, and you cannot ask the museum to bring out works that are not on display for you to view (I wish this were still possible, but today the size of collections prevents it). The experience of art on those terms ensures that people will feel like the museum is their house and that they are there to commune with art, to argue with it, to do whatever makes their juices flow, and they will visit frequently. This has not been the emphasis in museums for a long time and it is to their danger. The real audience may come for the blockbuster, but it returns again and again for more of what perplexed it the first time. In my experience, people come to MOMA repeating the same things that sceptics always say: they talk about the emperor's new clothes, they protest that 'my kid could do that' and so on. They are irritated by something they see and because they do not have the apparatus to deal with it, they mutter the same clichés. But they stay, they come back and eventually they ask themselves, 'Why would anybody have made that thing that way?' And once they begin to speculatively answer their own questions, all manner of things come together.

In my teaching days, I had a hopeless student who took a class of mine to fulfil the course requirements for graduation, thinking that art would be easy. I showed wide-ranging visual information including interviews from artists and slides – it was the 1970s and realism was powerful, so I showed some representational work – and this student was having none of it until it came to the paintings of Robert Ryman (b.1930), who has been widely ridiculed (fig.16). For some reason, this student perked up. It turned out that he had been a house painter, and knew exactly the nuances that Ryman was playing with in terms of the quality of paint. He just saw it in a way that people who were studying art or art history failed to understand; for him it was vivid, interesting and beautiful. What happens when your audience includes people like this student, for whom nothing resonates until they find one specific piece that hits that sweet spot? Out of that comes the capacity to wonder whether there are other things like that on view among the pieces you are offering them. That is how you win audiences. Not by servicing them, not by pleasing them and not by doing something to aggravate them either, which is a common strategy now among those who think that being a serious curator

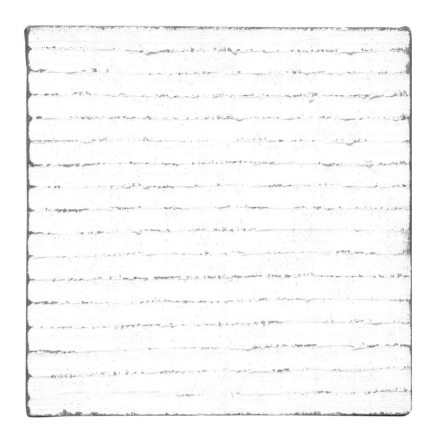

FIG.16 | ROBERT RYMAN (B.1930)
Untitled, 1965
Oil on linen 28.4 × 28.2 cm
The Museum of Modern Art, New York; Gift of Werner and Elaine Dannheisser

requires you to offend everybody. Instead, the key is to give people something that is worth their time experiencing and figuring out and then leave them to their own devices as much as possible.

Ann Temkin and Anne Umland recently curated a very beautiful exhibition of sculptures by Pablo Picasso (1881–1973) at MOMA (fig.17). One of them told me that it was based in part on the Ryman show which I brought to New York in 1993. I showed his work without any labelling, which was unheard of in major museums at that time.[7] The idea was to explore how the public would respond in an exhibition if they did not have any labels to read. What would they do if it was not explained to them? It was, in an institutional way, a critique of museums' lack of faith in the work itself, which they ascribe to the audience instead of acknowledging that their own institutional lack of faith is the problem. An absence of labels also means that nobody knows who loaned or gifted the work, which naturally prompted a lot of muttering among the patron class at the opening of the exhibition. However, the chairman of the board of MOMA, Ronald Lauder, was one of the lenders and on entering the show declared, 'I like this.' Once he had spoken, everyone else followed suit and agreed that they liked it too. It turned out that the Emperor liked nudity!

The point here is that when the public is thrown into a situation without an institutionally provided lifeline that is easy to grab and hold onto, then if they do not bolt right away they will, sooner or later, get around to just looking. Really looking, rather than rushing up to the label to see what the commentary has to say, or reading a date they do not really care about and will not remember or a name they cannot pronounce. They will begin to try and find their natural distance from the object and to scan it for information, for ways in which they might assimilate something related to it, so that they will not feel so uncomfortable. Once they stop feeling the completely understandable discomfort that strange new things almost inevitably inspire, they will start to see more, and once they see more they will want more. These are lessons too many of us have forgotten. In the desire to be user-friendly and educational – which is often manifested in a way that is not education at all, but is simply a form of marketing – we have lost faith in the general public. We have lost faith that they could actually find a place in modern

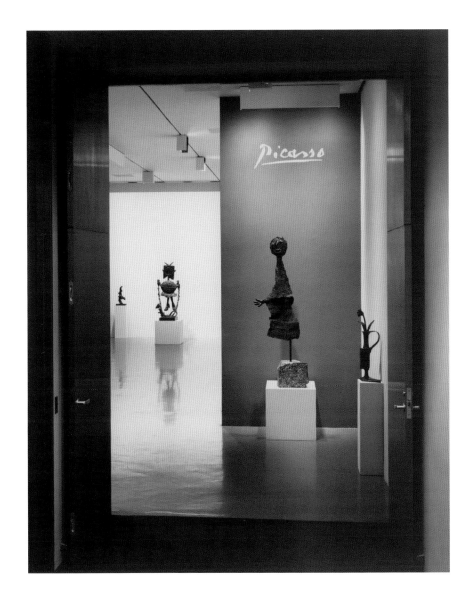

FIG.17 | *Installation view of the exhibition 'The Sculpture of Picasso'*
Museum of Modern Art, New York, 11 October, 1967 to 1 January, 1968
The Museum of Modern Art, New York

or any other kind of art that is their own and that will bring them back over and over again to see more.

Often these strategies of over-speaking, over-interpreting and over-nudging the audience are presented as a kind of democratic concern for people who do not know how to deal with the material. In fact it is the inverse: it is highly undemocratic to deny people that initial experience of alienation that is the predicate for creating their own place in these works. Most people will not flee; you are not causing them pain or deliberately scorning them. You might be patronising them by talking down to them, but not by trusting that they will find a way in. As for those who choose to walk away, the real question is: do they come back? When they return, do they see this thing that perplexed them in a different light? You have to have faith that the art itself is that good and that the public is that able.

Virgil Thomson (1896–1989) was an artist who also wrote music criticism for the daily New York papers. He wrote about music that was avant-garde at the time, as well as very tough reviews of the performance practice of classical musicians. His motto was, 'Never underestimate the public's intelligence, and never overestimate its information.'[8] These days, museums regularly do too much of both. Information should certainly be provided but consideration should also be given to when it is provided, how, and in what quantity. At the same time, it should always be assumed that the public are more intelligent than they might appear. So, how do museums begin to think about the public to be guided through this maze of conflicting information, different experiences and different degrees of alienation? How does one reach them in ways that allow them to use their own aptitude, their own capacity to decide to go for something when they themselves want to rather than when you want them to?

I want to recount an anecdote about Dorothy and Herbert Vogel (b.1935 and 1922–2012). She was a public librarian for the city of New York and he was a postal sorter, and together they attended more openings than anybody I know of, including Andy Warhol. Early in their courtship, they considered becoming artists and took courses in making art, before concluding that it was not for them. Then they started taking art history courses at settlement houses, which were still flourishing at that time, and, having fared better at that, they decided to shoot for

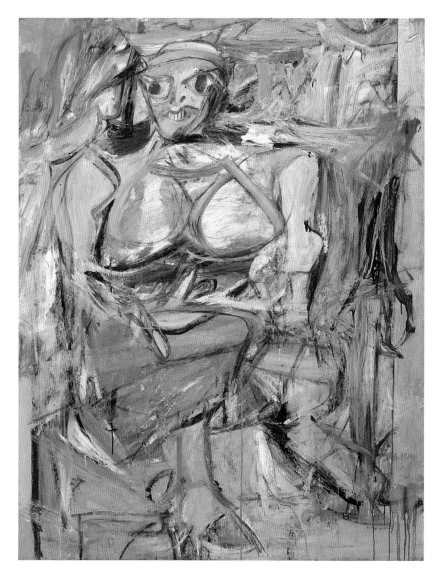

FIG.18 | WILLEM DE KOONING (1904–1997)

Woman, I, 1950–1952

Oil on canvas 192.7 × 147.3 cm

The Museum of Modern Art, New York; Purchase

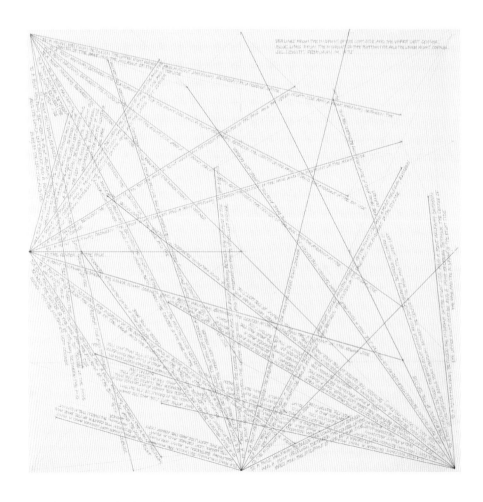

FIG.19 | SOL LEWITT (1928–2007)

FIG.19 | SOL LEWITT (1928–2007)
Red Lines from Midpoint of the Left Side and the Upper Left Corner, Blue Lines from the Midpoint of the Bottom Side and the Lower Right Corner, 1975
Red and blue felt-tip pens with graphite on wove paper **38 × 38 cm**
National Gallery of Art, Washington, DC; The Dorothy and Herbert Vogel Collection, Ailsa Mellon Bruce Fund, Patrons' Permanent Fund and Gift of Dorothy and Herbert Vogel

the moon. They went up to Columbia University and took courses with Meyer Schapiro (1904–1996), one of the great art historians of all time. Schapiro introduced Americans to Freudian, Marxist and semiotic art history as well as being a specialist in mediaeval French art and modernism. He taught Willem de Kooning (1904–1997) about things that allowed him to finish *Woman, I*, introducing him to ancient art history: Cycladic art and so on (fig.18). He talked to Fernand Léger (1881–1955) about the mediaeval Spanish Beatus manuscript that helped Léger to make work. Schapiro was able to connect the dots between artists and non-artists and to draw links between different eras.

The self-educated Vogels got the bug and started to collect conceptual and minimal art in the days when a drawing by Sol LeWitt (1928–2007) cost a hundred dollars and one by Richard Tuttle (b.1941) probably not much more (fig.19). They collected voluminously: not one or two examples, but three or four – or dozens. The artists were so pleased by the couple's interest that even after prices went up they charged them a special Vogel price. The couple lived in a rent-subsidised apartment in Manhattan that was full of cats and smelt accordingly. Under every bed, on top of every surface – beds included – in the closets, in the bathroom, there was art. This continued right up until Herb's death, and Dorothy still collects today.

In later life, when they had been collecting for many decades, they were approached by the National Gallery of Art in Washington, DC and asked if they would be willing to donate some of their works. They agreed to give some of their collection, which today forms the core of the Gallery's most radical work of the 1960s and 1970s: a remarkable gift, from a postman and a librarian who were on civil service salaries yet are among the greatest patrons the museum has ever had (fig.20). However, they decided to break their collection up into several slices, and other works were given to museums around the country, including the Yale University Art Gallery. This is the story of the success of Barr's experiment. He created MOMA in 1929 during the Depression, when the general taste of the American public was for genre painters. He persuaded this very resistant public to take Picasso, Joan Miró (1893–1983), Matisse and others seriously, and subsequently to take other things seriously too. Two of the people he persuaded

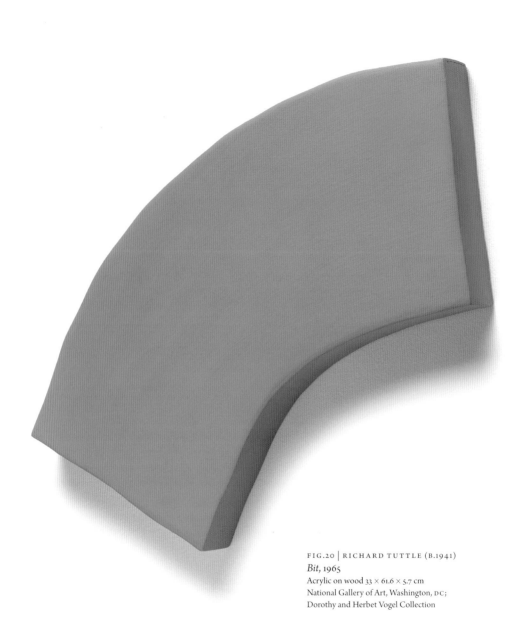

FIG.20 | RICHARD TUTTLE (B.1941)
Bit, 1965
Acrylic on wood 33 × 61.6 × 5.7 cm
National Gallery of Art, Washington, DC;
Dorothy and Herbet Vogel Collection

were these civil servants, who in turn gave back to the nation so that curators can shuffle the deck over and over again, telling different stories or, sometimes, simply providing a visual and intellectual experience which is there for its own sake. In providing this, museums are furthering a public forum for the arts, rather than furthering a case for one specific agenda within the arts.

This is something that all museums can achieve. In an institution such as the National Galleries of Scotland, where the architecture and collection offer fewer occasions for altering the presentation, opportunities to do so do nevertheless exist and these should be taken advantage of. When the major masterpieces are away on loan, that is a perfect time to bring out the work people are less familiar with, or works that some people think are great but that others are less sure of. With those works in full view one can convene an argument about whether these pictures hold up and whether they look better than the more famous works, even though we are told to think that they do not.

Such arguments should be the hope of museums, the guarantee of their future. The more that museums freeze into temples of art, temples to patrons and artists, the more they lock into instrumentalising ideas about the public – Is it against us? Must it be sold on art that isn't easily likable, instantly understood? – the more museums back themselves into a corner. However, if these adversarial, belittling conceptions of the art's potential audience are turned around and we come to believe instead that museums are public institutions in which anybody can potentially find a stake of their own, then the situation is less grim than sometimes painted. I am an optimist. My hope is that ours will not turn out to be the age when museums froze, but rather the period when institutional critique started to be done from the inside as well as from the outside and when both these institutions and the culture at large were much the better for it.

NOTES & REFERENCES

1. Ezra Pound and Michael Dirda, *ABC of Reading*, New York, 2010, p.25.

2. Frank O'Hara, *Art Chronicles: 1954–1966*, New York, 1975, p.52.

3. Fernando Pessoa, trans., ed. Edwin Honig and Susan M. Brown, 'Christmas', *Poems of Fernando Pessoa*, New York, 1986, p.142.

4. As quoted in Nicholas Fox Weber, *Patron Saints: Five Rebels who Opened America to a New Art, 1928–1943*, New Haven, 1995, p.4.

5. F. Scott Fitzgerald, ed. Edmund Wilson, *The Crack-Up*, New York, 1993, p.69.

6. The exhibition was DISLOCATIONS, held at the Museum of Modern Art, New York, from 20 October 1991 to 7 January 1992.

7. Robert Ryman was shown at The Museum of Modern Art, New York, from 26 September 1993 to 4 January 1994.

8. See Virgil Thomson, ed. Tim Page, *Music Chronicles: 1940–1954*, New York, 2014.